Bloomberg
newcontemporaries
2005

Venues

4 June – 17 July

Cornerhouse
70 Oxford Street
Manchester M1 5NH

10 September – 16 October

LOT
Corner of Penn Street
and Broadweir
Broadmead
Bristol BS1 4AW

Spike Island
133 Cumberland Road
Bristol BS1 6UX

16 November – 8 January 2006

Barbican Art Gallery
The Curve
Barbican Centre
Silk Street
London EC2Y 8DS

Bloomberg
newcontemporaries
2005

Selectors
Jeremy Akerman
Phil Collins
Jane and Louise Wilson

Sponsor's Foreword

Bloomberg is proud to sponsor New Contemporaries for a sixth consecutive year. Bloomberg New Contemporaries offers a much needed platform for young artists, providing them with an opportunity to gain wider recognition and to be part of a highly respected process.

Bloomberg is the world's leading global financial information services, news, and media company. Headquartered in New York, Bloomberg has operations in more than 55 countries. Bloomberg provides real-time news, financial data and communication tools to corporations, professionals and individuals around the world through the BLOOMBERG TERMINAL℠ and Bloomberg's worldwide news operations.

Bloomberg has a strong commitment to education and to expanding access to art, science, and humanities. A major supporter of educational and cultural institutions worldwide, Bloomberg sponsors a wide range of educational and artistic initiatives – from exhibitions, to student fellowships, to public art installations – that promote both public awareness and appreciation of art.

Bloomberg New Contemporaries 2005 will showcase a group of 29 excellent young and emerging artists selected from over 1100 submissions. Bloomberg is pleased to introduce this year's selection, which will tour Manchester and Bristol, before opening in London in November 2005.

Foreword

Sacha Craddock
Chair of the Board of Directors

It is exciting to imagine how New Contemporaries will be this year. At this stage the selectors have seen the work for real, chosen from films repeatedly watched, proposals reconsidered, paintings moved, hung, taken down and reviewed. The resulting exhibition, consisting of work by only a few artists chosen from such a huge submission, will include also prints, photographs, and a substantial element of direct and insistent sculpture, to be a revelation in terms of current practice and past New Contemporaries.

It is always important to combine the smooth regular heart beat of this fair and democratic selection process with the specific nature of the selection and application. Of course, selectors vary each year in the way they work together, but I really want to thank and congratulate this year's selectors for the open, free and intelligent way in which they have approached all of the work brought before them. Really this show brings a strong, hard hitting and direct range of work to the public and I am happy that New Contemporaries continues in style. I want to thank James Moores, Bloomberg, and the Arts Council for their continuing trust and support.

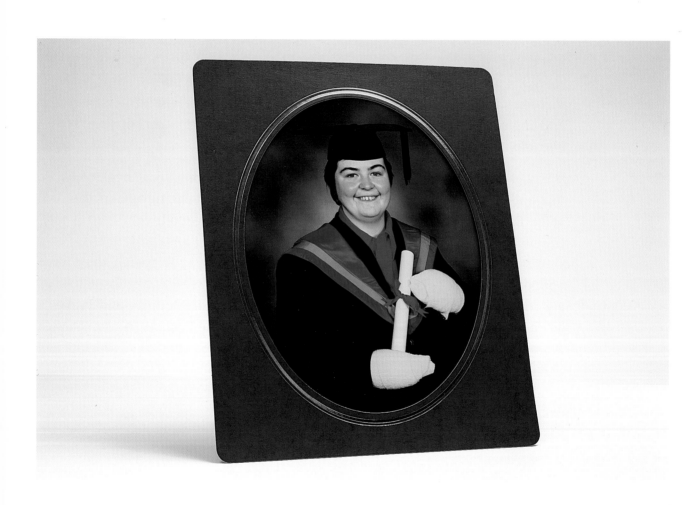

Josephine Flynn
Graduation, 1998
Photograph

News from the bunker

Jeremy Akerman

In her short essay 'Against Interpretation', Susan Sontag defends the work of art as a sensory experience and calls upon us to 'learn to see more, to hear more and to feel more'. The first morning we nervously sat down to encounter the thousand plus entries to the Bloomberg New Contemporaries, Sontag's call was roughly the advice repeated to us, the selectors. I'd be hard pressed to think of another week where I have had to see, hear and feel as much in such a concentrated period: being a New Contemporaries selector was both fantastically invigorating and uniquely knackering.

Later in her essay Sontag asserts 'our task is to cut back on content so that we can see the thing at all'. This makes sense as a way of explaining the selection process – occasionally work comes up that defies standard interpretation and makes one reconsider, things that at first appeared clever suddenly seem less bright. I'm not for a moment advocating some unthinking process here, but rather an informed, earthy and living engagement that can evolve. There was a wide range of experience and knowledge on the panel and I was amazed by the precision of the specialist comments the other selectors frequently plucked out of nowhere. So saying, I think our selection panel would have made Sontag happy because we responded instinctively with all senses firing. (No-one submitted any art involving smell, by the way: clearly there's a gap in the market.)

The week began in the bowels of the Barbican in 'The Last Stand', a bunker of a room with a heating system that worked intermittently necessitating a series of electric heaters all running off the same

overloaded extension lead. It was the perfect space to contain the madness. I say madness because by rights looking at ten thousand pictures in a week should send you bonkers. Waiting for us in this ominously named room, was a mile of boxes and files containing slides, videos, DVD's and so on. Each box a concentrated lump equalling two or three degree shows worth of art. The days were therefore carefully mediated with breaks and each little escape felt like leaving the cave and its shadows, returning to the world once more to smoke the ubiquitous Marlboro light, astonished to see sunshine.

What did we see? Well, some amazing, unexpected sculpture: not 3D illustrations but poetic stuff, tough and unselfconscious quite able to take to the floor (Jenny Dunseath and Christopher Walker). There was a lot of superb painting, which I had expected and which sparked the best arguments (Andrew Graves). We saw a tiny bit of print but enough to excite us (Nelson Crespo). (One thought on print here – why is there so little print around? Is the print room still the leper colony of art college?) Not so much photography (Muzi Quawson) but generally of a high standard and, thank God, not much video (although quite enough of the 'I shot this whilst driving my car' variety) (exceptions here are Craig Wilson, Katie Davies). And then something out on its own like banners! Or film! (Craig Coulthard, Mark Boulos). It's funny: you find yourself looking for something never seen before but how would you know what that looked like? I intended not to mention favourites but those named above are mine. This year a favourite theme that cropped up time and again was landscape – every kind of landscape from middle-earth to psycho-geography and back again. Despite all the landscapes entered almost none have made it through to the show. No-one seemed to have been able to just make a picture of it.

It's a lot easier said than done I know but after all the interpretations we were crying out for a landscape that wasn't a stage set for the 'geddit' idea.

New Contemporaries like any decent military operation is staffed by an excellent team. As a process it is even handed, if a DVD jammed it was held back till it could be played and videos and slides were looked at several times over if there was any doubt as to what was going on in them. I liked how everyone in the bunker was able to express their opinion, especially those manning the projectors; I am sure they would have expressed their opinion whether we liked it or not.

Days four and five were when the cracks began to show for the selectors. I was spending more and more time escaping to the bright lights in the industrial kitchen, rummaging around in the walk-in fridge, picking at the dwindling supplies like you do at home after a long Christmas. Phil Collins, the funniest man I have met for a very long time, lay in a darkened corner one morning watching the projection screen from the back muttering to himself. He returned to the rest of the panel in the guise of yet another of his invented personas complete with catch phrase. (He's like a mix of Dame Edna, Kenneth Williams and Mrs Doyle from Father Ted.) The Wilson sisters' communication, beautifully synchronised at the beginning of the week, became fragmented by the end; their speech between each other spartan and code-like and I began to suspect telepathy. Meanwhile the boys on the projectors (Tom and Mr Dude) drove us relentlessly on like Captain Ahab after the whale, no longer resting lest we get washed up in the shallows. Suddenly though, out on the horizon, something wonderful would come into view; somebody's work dazzled us afresh and we'd sing out in unison, "that's in" and continue on our way, energised by the discovery.

The shortlist completed, we re-convened some weeks later to meet the artworks on the 7th floor of the Bloomberg office complex, a sharp contrast from 'The Last Stand' (like fast- forwarding from 1970 to 2010). The Bloomberg building is all glass and steel with vast office spaces the size of football pitches. It is shockingly apparent what has potential for being shown; what has that tiny bit of necessary content and innate sense of itself and the production values to see it through. So much is communicated, not only material properties but also the conversations around its making – the level of critical discussion that has informed, dominated or liberated.

This second phase of selection was two long days walking around the artwork, moving the artwork around us, subtracting and adding until satisfied. Often paintings were hung on two or three different walls to see the full range of how they worked; installations were interrogated and videos played and re-played. It reminded me of old maxims about curating an exhibition. There are different approaches: the first is that you make a model (plan) and then install the work to make the argument; another is that you bring all the work in and then move it around the space until exhaustion decides the day. We did a bit of both but the emphasis quite rightly was on the physical engagement with the work at Bloomberg. There is nothing to replace the energy that physically engaging with artwork produces and it is this activity that can bring an exhibition to life. Too often one can see the discrepancy between the intention for a work of art and what the artwork is actually doing in the space. The curatorial responsibility is to show the work as best as possible and this affected our decision making as selectors.

Occasionally promising work wasn't appropriate for a gallery, or promising ideas did not materialise. I wish in some ways that those who entered could see how their work was seen, moved from one

spot to another and was this physical entity for us; it would give them an insight to what they've produced and perhaps solve some of the more obvious problems. I think it would help for art students to let others organise their work from time to time – after all that's what curators will do once they get their enthusiastic hands on the their work. Artists need a peer group and art college is a good place to start: they need critical dialogue and very often leaving college means the end of the discussion, so it's imperative for young artists to find a way to protect themselves and include themselves into the wider debate. There is no virtue in isolating oneself away working hard and waiting for the knock on the door. It won't happen.

In the end one has to go with what seems to be working best. Fortunately for us selectors what New Contemporaries brought us was very good. Let me make one last point. This isn't another make over show where a person suddenly gets to play artist, nor is it about greatest art hits of 2005. Society's obsession with listing and scoring our top one hundred betrays a curious insecurity about the present day. This exhibition is an alternative, an antidote; a good show by people who have decided to see, hear and feel more, I hope they go on doing so for a long time.

Open to all final year undergraduates and current postgraduates of Fine Art at UK colleges and those artists who graduated in the year 2004

Mark Boulos

Dwight Clarke

Craig Coulthard

Nelson Crespo

Katie Davies

Jenny Dunseath

Erica Eyres

Josephine Flynn

Andrew Graves

Anne Kathrin Greiner

Hideko Inoue

Takahiro Iwasaki

Elizabeth Lee

Stuart McCaffer

Richard Mosse

Clive Murphy

Beltran Obregon

Robert Orchardson

Bruno Pacheco

Giles Perry

Muzi Quawson

Charlotte Rea

Jaume Simo Sabater Garau

Martina Schmuecker

Payam Sharifi

Chris Smith

Robert Stone

Christopher Walker

Craig Wilson

Mark Boulos
The Gates of Damascus
Digibeta
25mins

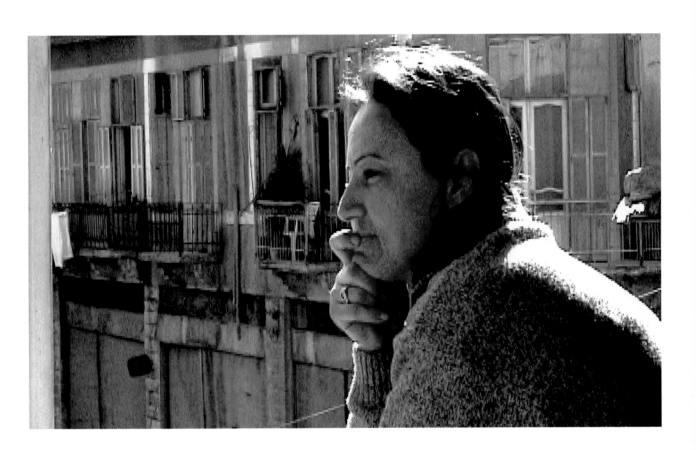

Dwight Clarke
Only You Can Do It
Acetate vinyl and audio equipment

THE EXCHANGE

Side B

DWIGHT CLARKE

33⅓ rpm

1. ACOUSTIC GUITAR
2. VIOLIN
3. PIZZACATO
4. VOCAL
5. COMPLETE SONG

STRINGS SECTION

42 Bruges Place · Randolph Street · London NW1 0TX · Tel. 020 7485 0530 · Fax. 020 7482 4588

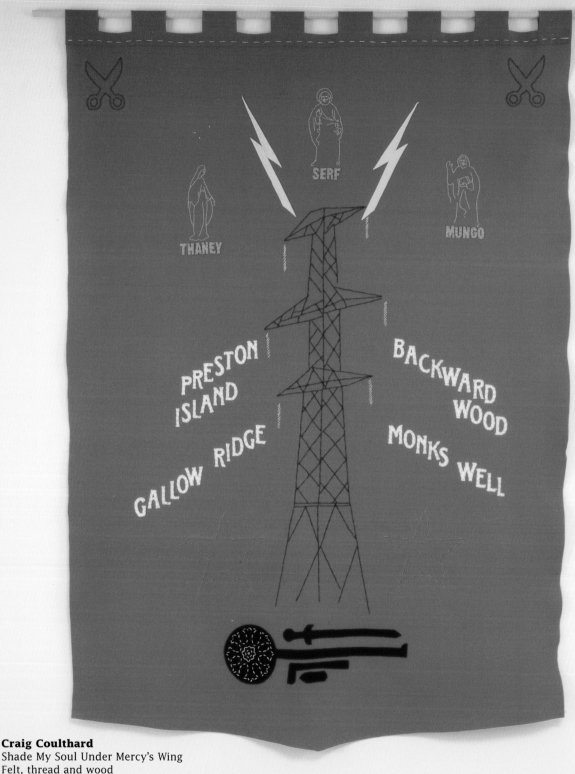

Craig Coulthard
Shade My Soul Under Mercy's Wing
Felt, thread and wood
For West Kirk Culross, Fife

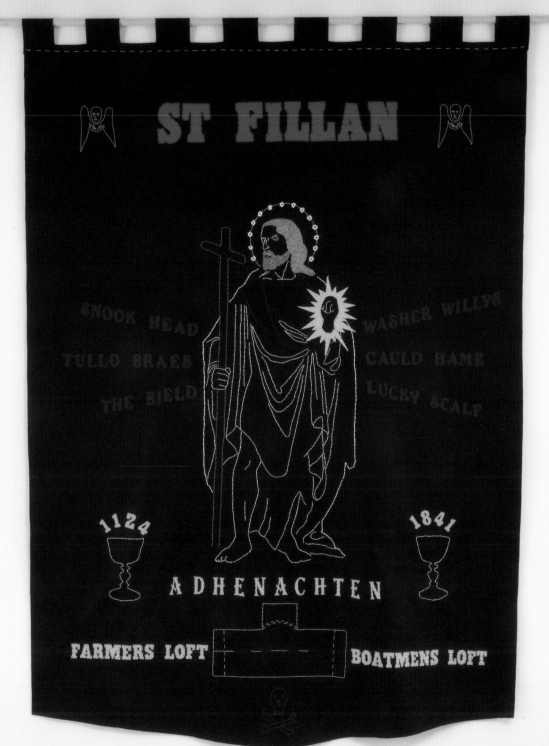

Craig Coulthard
Convincing The Wolf Of The Error In Its Ways
Felt, thread and wood
For St. Fillans Church, Fife

Nelson Crespo
Schrift
Lithograph

Vorname: *Nelson* Name: *Crespo*

Nelson Carreiras Crespo

Nelson Crespo

Nelson Crespo Datum: *18.10.86*

Nelson Crespo

~~Nelson Crespo~~

Nelson Carreiras Crespo

Nelson Crespo

Nelson Crespo

Klasse & Zimmer?

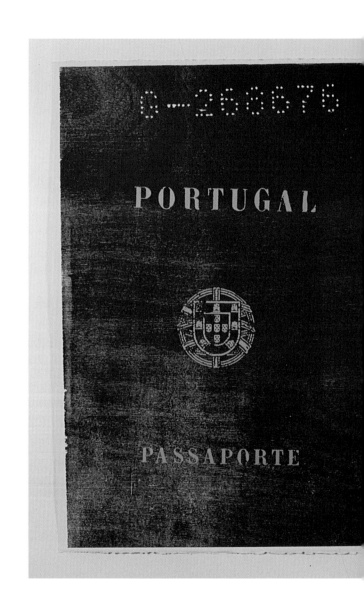

Nelson Crespo
Portuguese Passport (triptych)
Woodcut, screenprint and monoprint

Vistos — Visas

Vistos — Visas

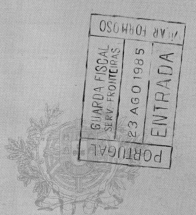

Katie Davies
Looking for Abraham
DVD projection
4mins.05

Jenny Dunseath
Tunnel
Paper and gum strip
60 x 100 x 160cms

FOLLOWING SPREAD
Jenny Dunseath
Skis
Cardboard and papier mache
110 x 130 x 170cms

Jenny Dunseath
Package
Cardboard, foam and wood
120 x 120 x 110cms

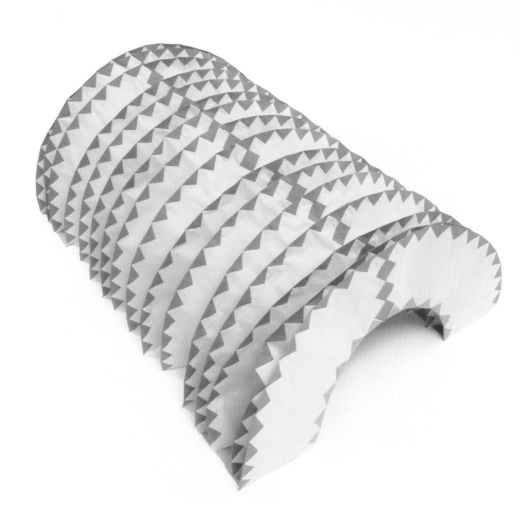

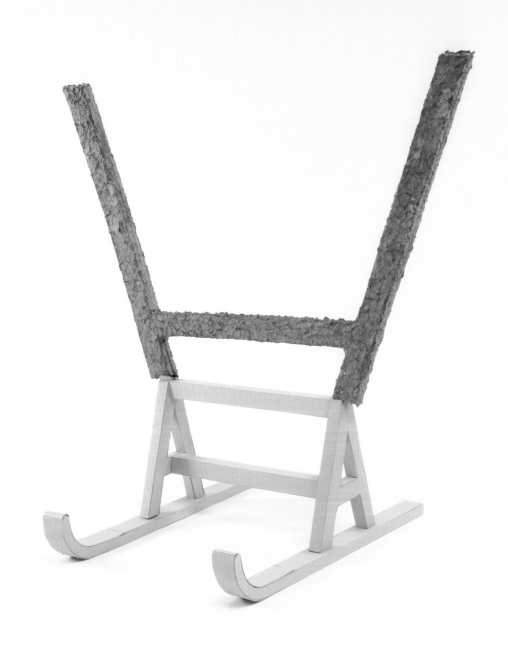

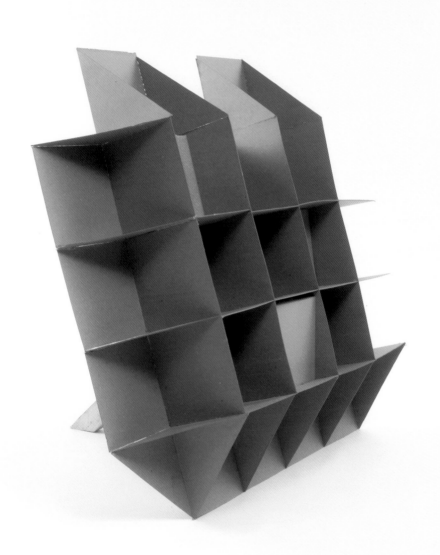

Erica Eyres
Playing Dead
DVD
4mins.03

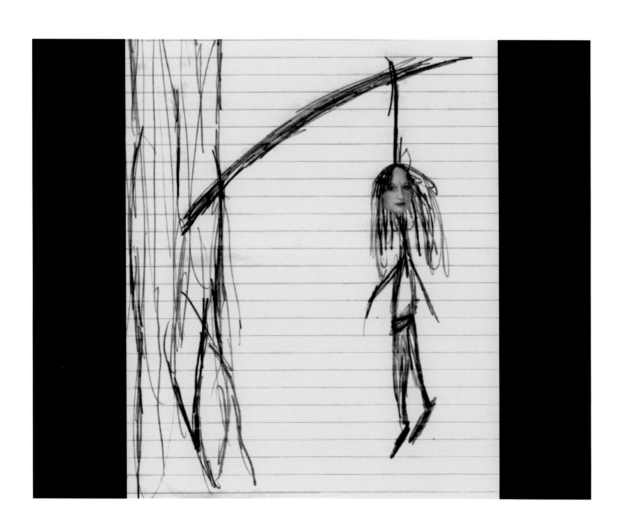

Erica Eyres
Playing Dead
DVD
4mins.03

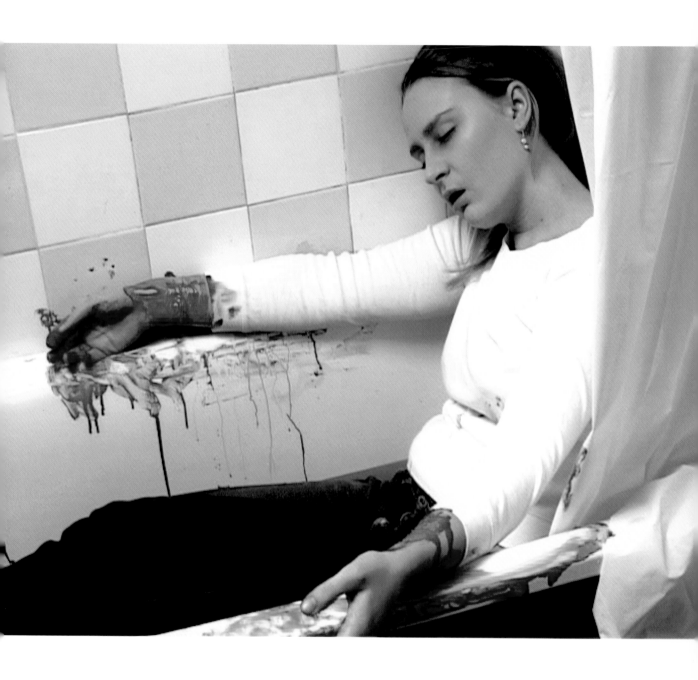

Andrew Graves
The Lounge
Oil on canvas

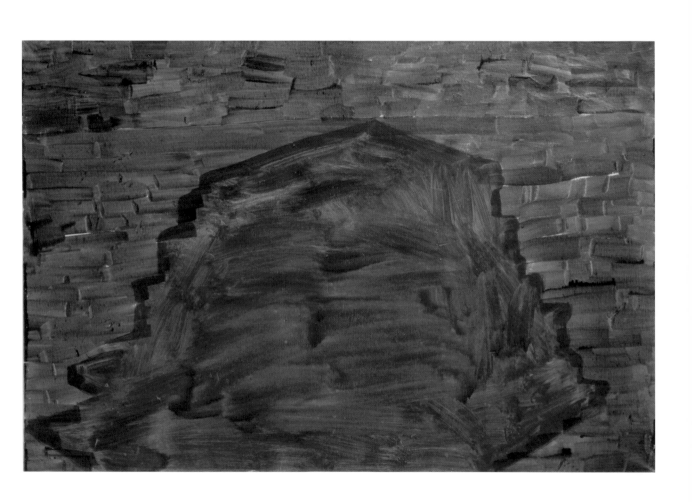

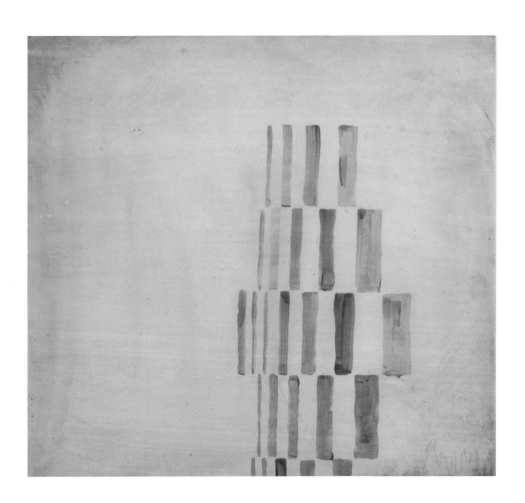

Andrew Graves
Untitled (olive)
Oil on gesso board

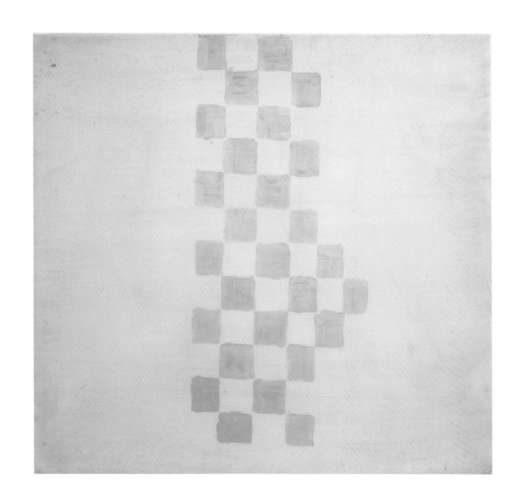

Andrew Graves
Eddy
Oil on gesso board

Anne Kathrin Greiner
Untitled 5
From the series Wa
C-type print

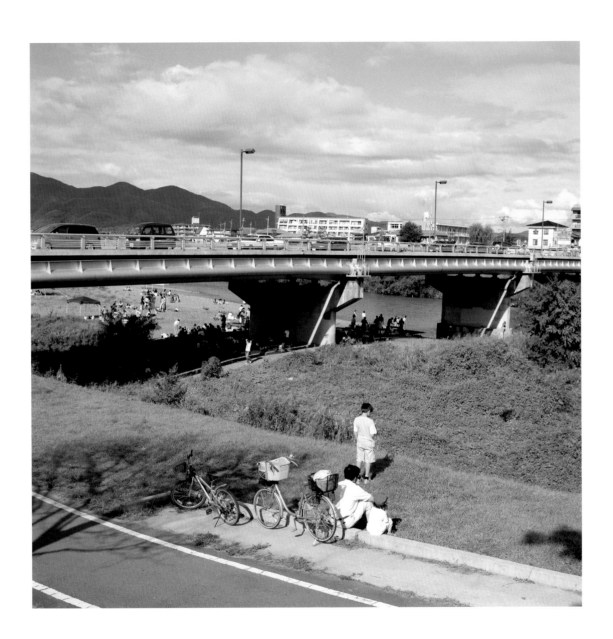

Anne Kathrin Greiner
Untitled 2
From the series Wa
C-type print

Anne Kathrin Greiner
Untitled 4
From the series Wa
C-type print

Anne Kathrin Greiner
Untitled 7
From the series Wa
C-type print

Hideko Inoue
The Scarf II
Oil on canvas

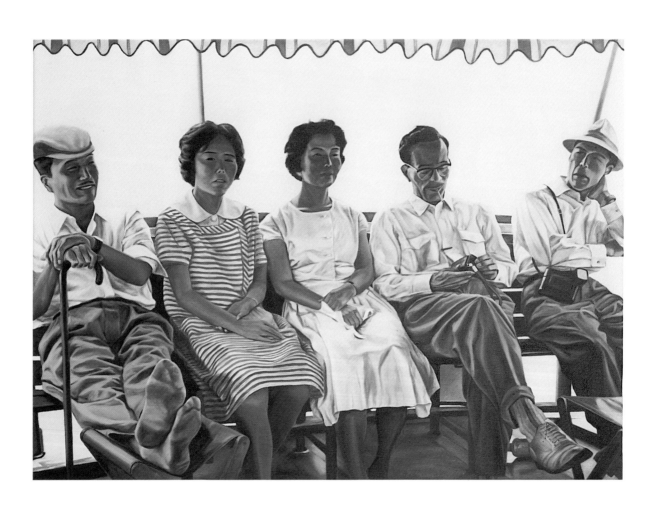

Hideko Inoue
The Hat
Oil on canvas

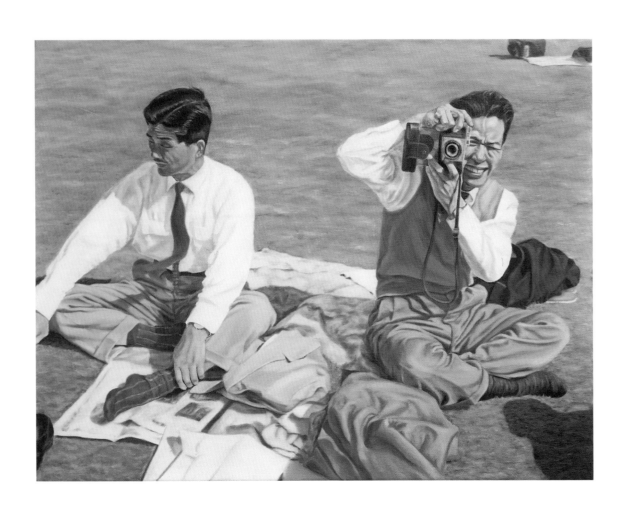

Hideko Inoue
The Tie
Oil on canvas

Takahiro Iwasaki
Differential/Integral Calculus
Pencil lead, eraser, vinyl tape and thread

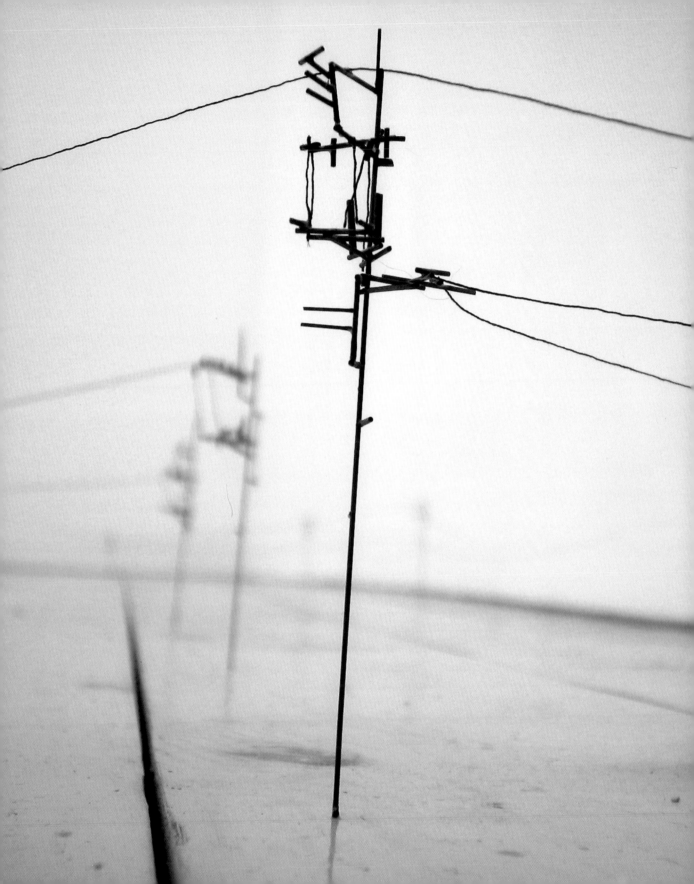

Elizabeth Lee
Stanley Dog of War
DVD
2mins.02

HARRY TAKES A HOLIDAY

CONNECT

Aktenhülle mit Reiter
nise dos refoulé

Dossiermap

Subcarpeta de
esquinas rectas

Aktomslag

Asiakirjakansio manilla

Δίφυλλο χαρτόνι
με ράχη

square-cut
folders

foolscap

Q

Windsworth

Fred Dunham

REF: kmh KF23025
DAUGHTON

Stuart McCaffer
Harry Takes A Holiday
Mixed media
14ft x 12ft x 8ft

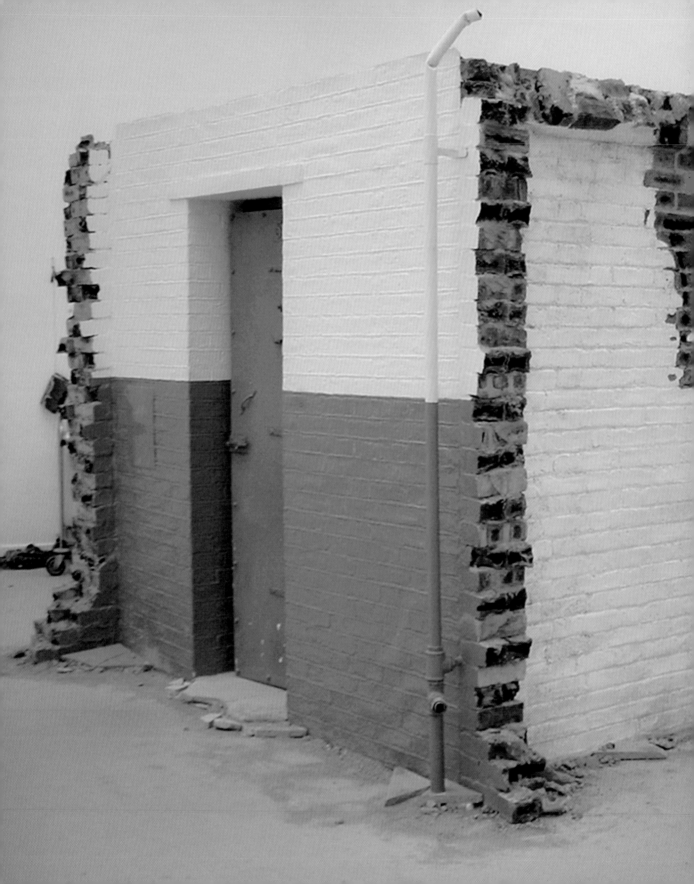

Richard Mosse
Untitled
C-type photographs on aluminium

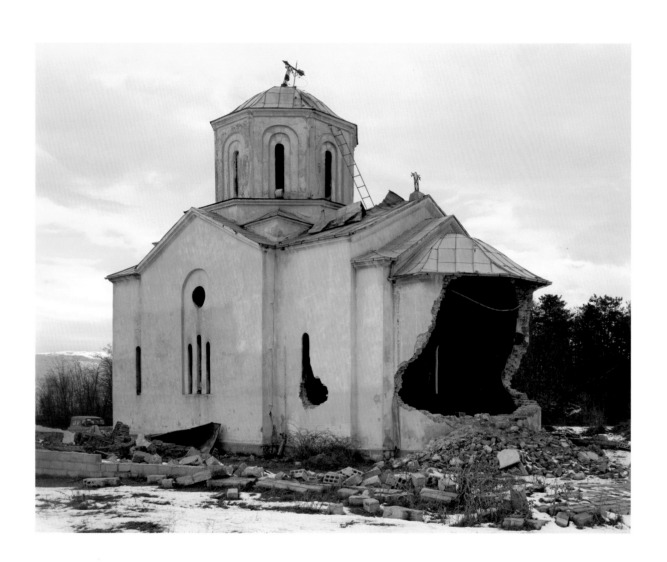

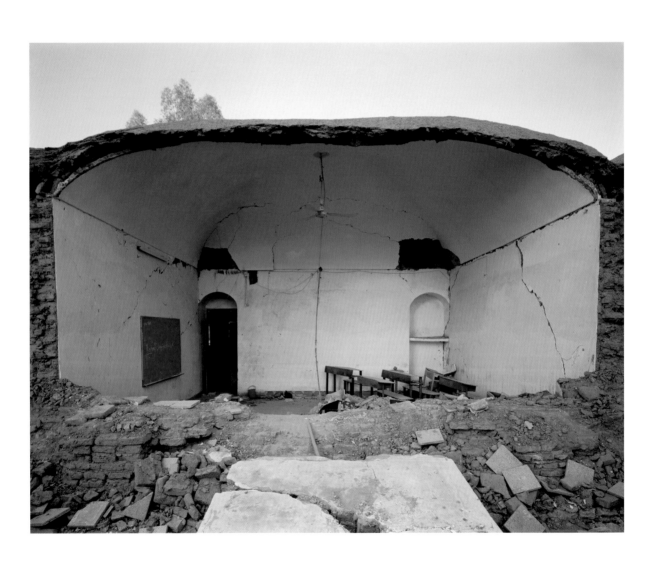

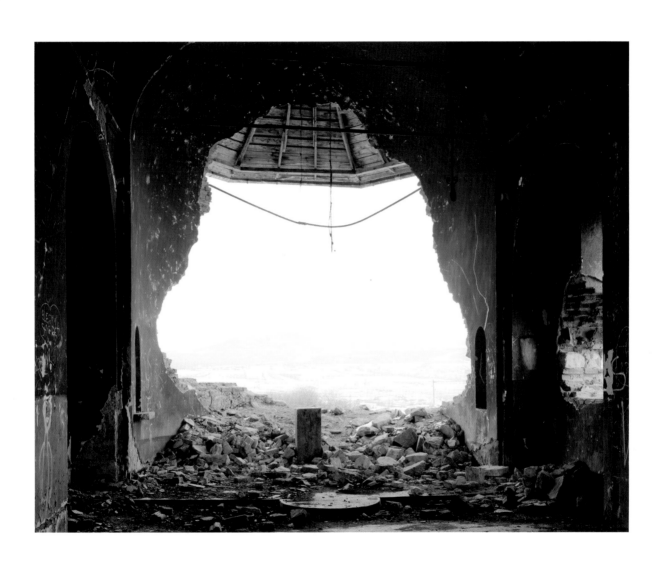

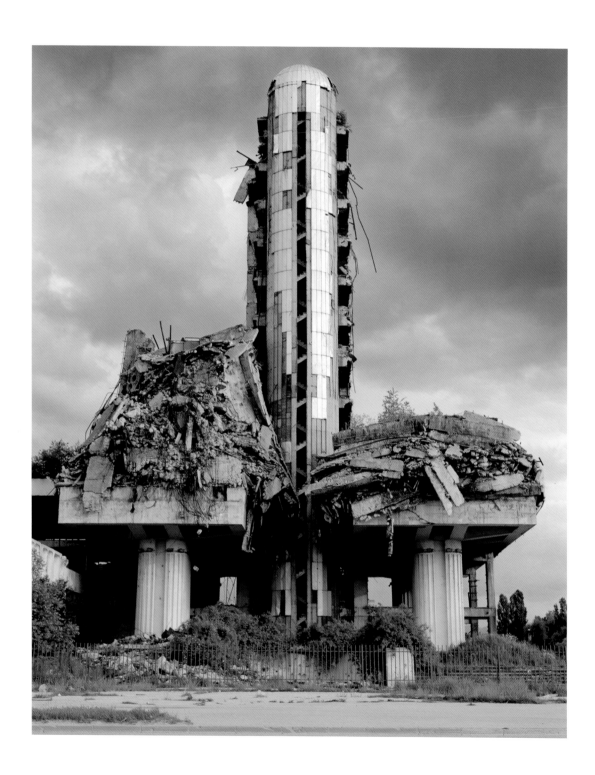

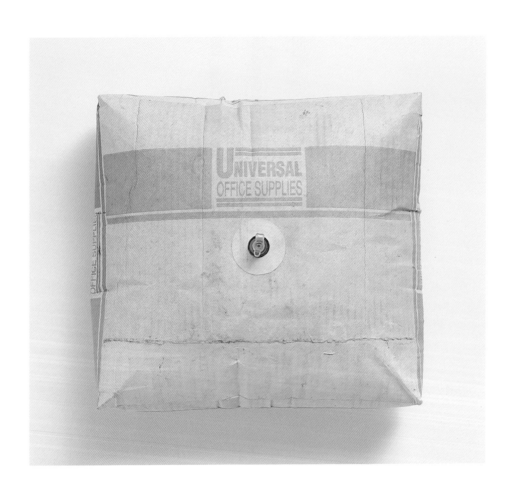

Clive Murphy
What It's Like To Be Me
Inflatable cardboard box
30 x 30 x 12cms

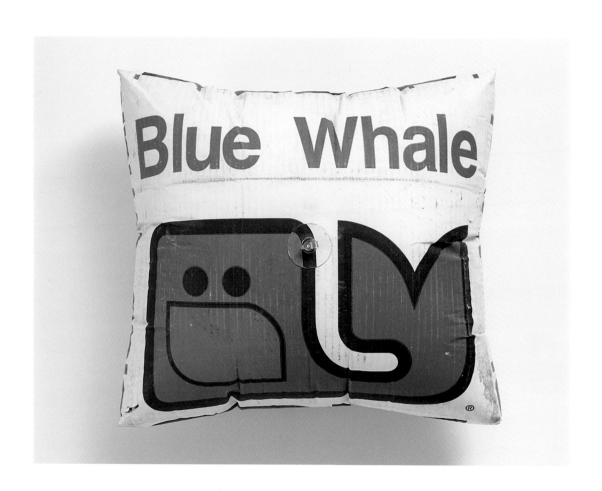

Clive Murphy
You Drive Me Crazy
Inflatable cardboard box
63 x 55 x 44cms

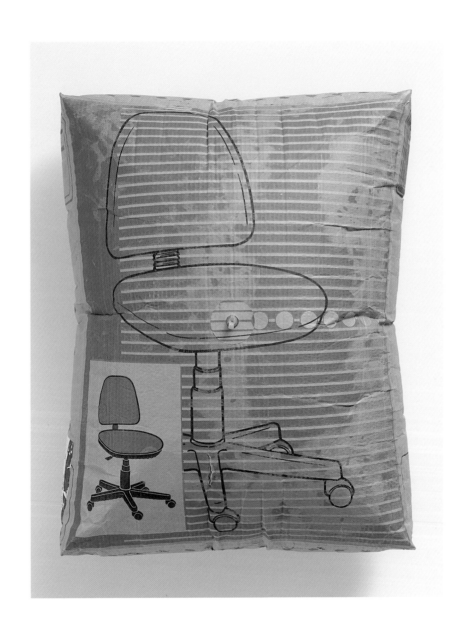

Clive Murphy
One Kiss From You
Inflatable cardboard box
78 x 59 x 38cms

Clive Murphy
I'm A Slave 4 U
Inflatable cardboard box
97 x 46 x 43cms

Beltran Obregon
Gazing at Heaven
Slide projection

Robert Orchardson
Symmetriad
Sapeli wood
400 x 220 x 3cms

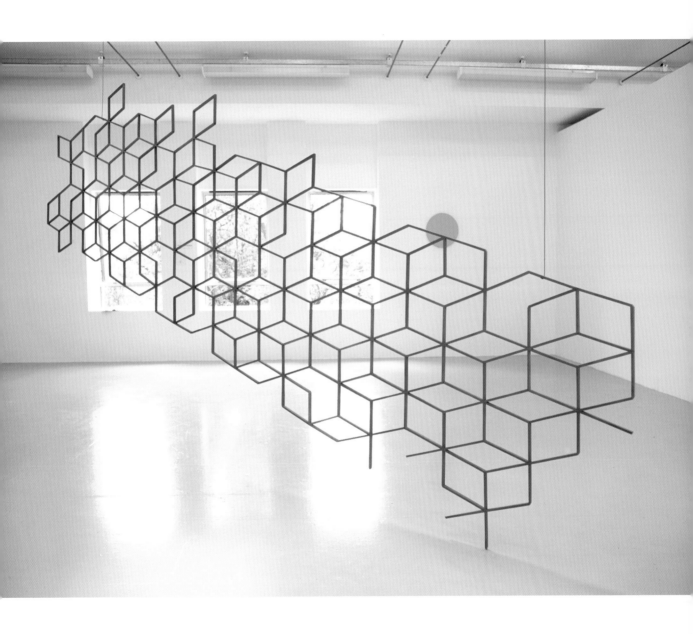

Bruno Pacheco
With The Back To The Rain
Oil on canvas

Bruno Pacheco
Enguard (Souvenirs)
Oil on canvas

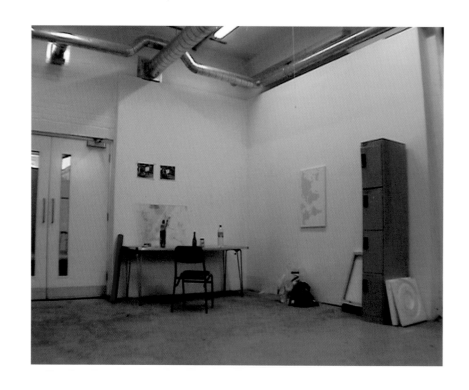

Giles Perry
Quake, New Cross
DVD
56 secs

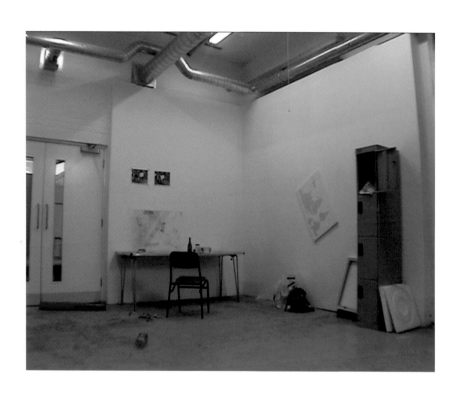

Muzi Quawson
Asbury Park
Pull Back The Shade
Slide projection

Muzi Quawson
Amanda and Hominy
Pull Back The Shade
Slide projection

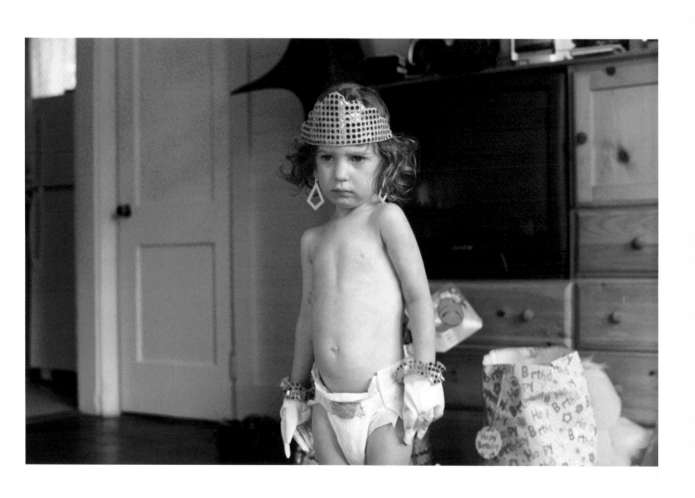

Muzi Quawson
Hominy
Pull Back The Shade
Slide projection

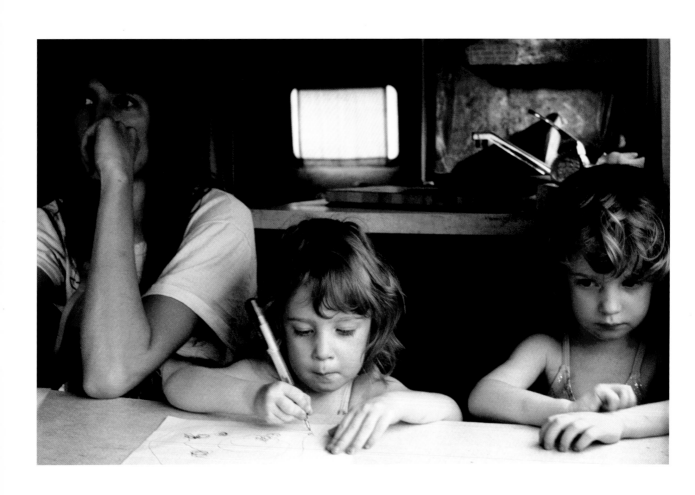

Muzi Quawson
Camper
Pull Back The Shade
Slide projection

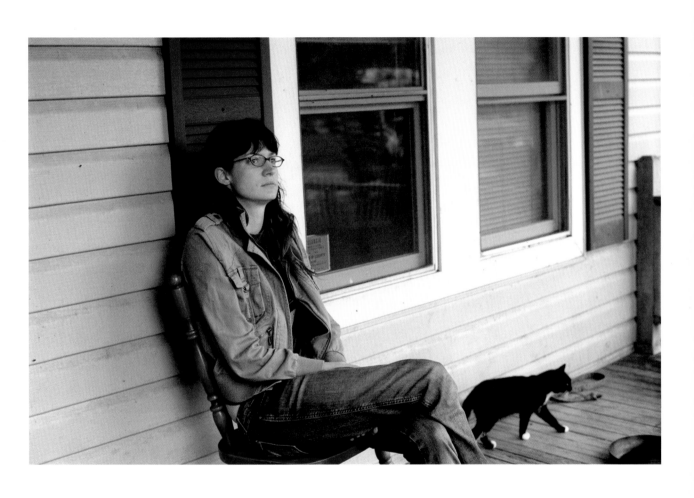

Muzi Quawson
At Lisa Smallwood's House
Pull Back The Shade
Slide projection

Charlotte Rea
From the series Emergency Accommodation
Photographs

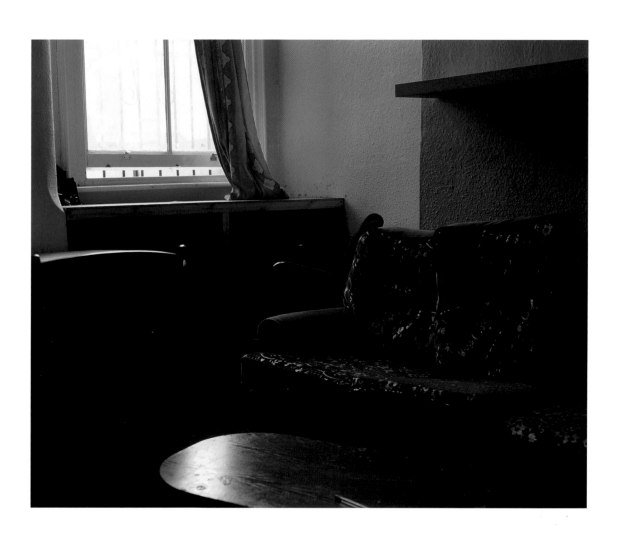

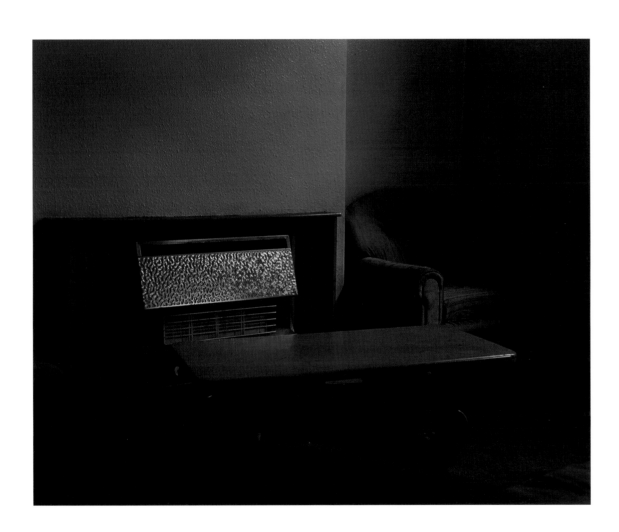

Jaume Simo Sabater Garau
Lotta VII
Mixed media
400 x 300 x 300cms

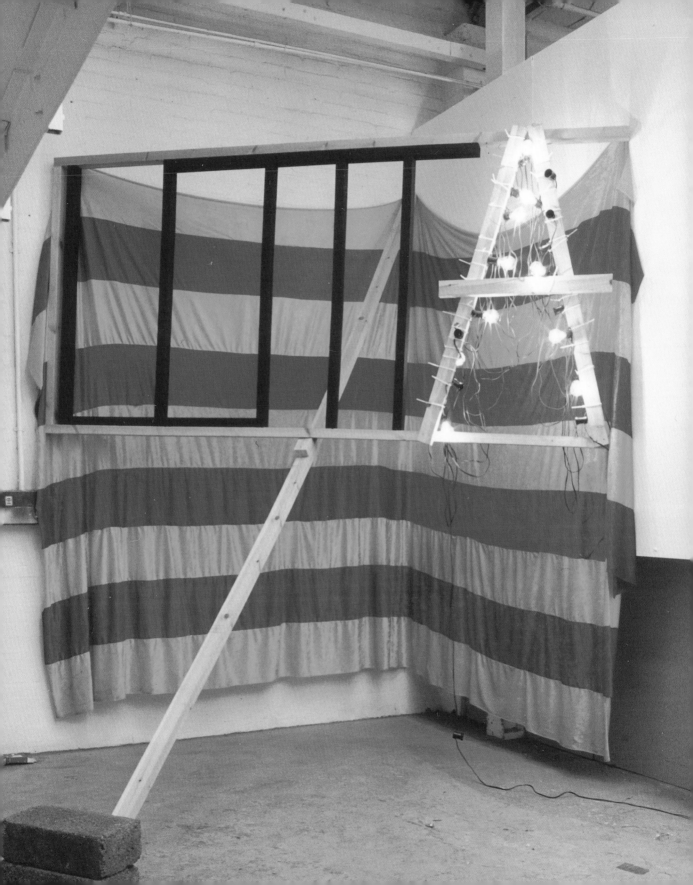

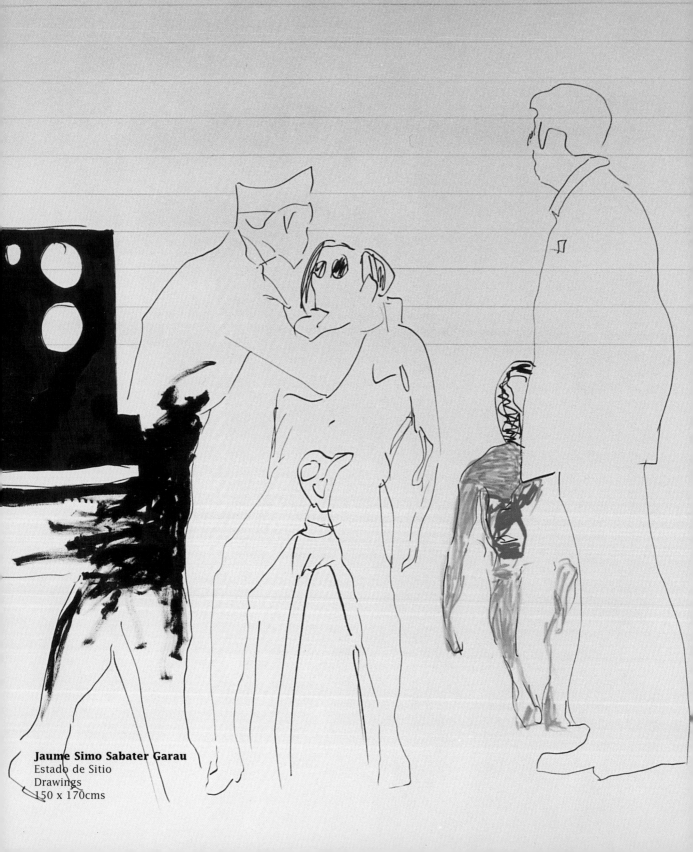

Jaume Simo Sabater Garau
Estado de Sitio
Drawings
150 x 170cms

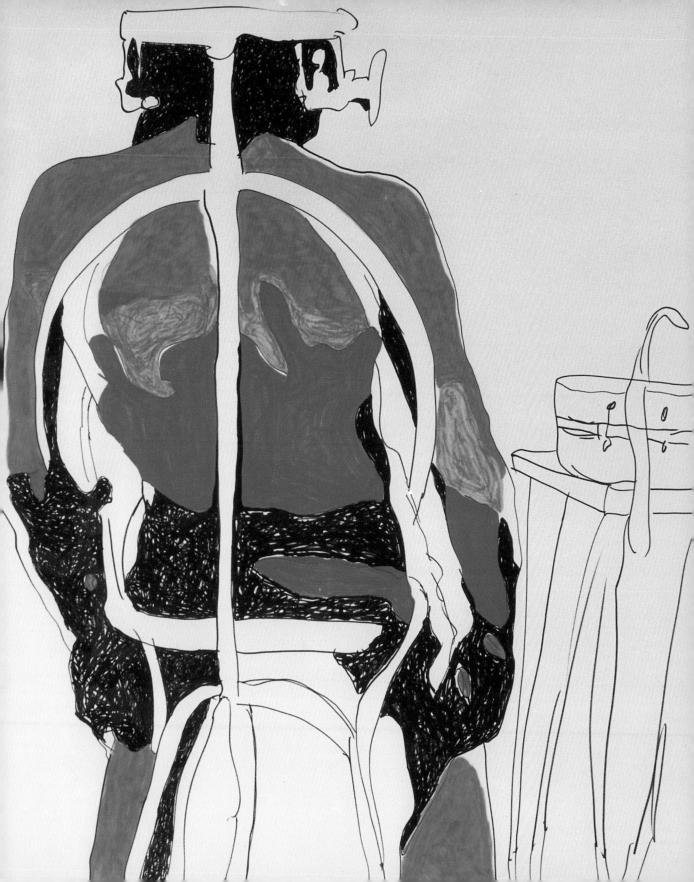

Martina Schmuecker
Auszeit
Performance

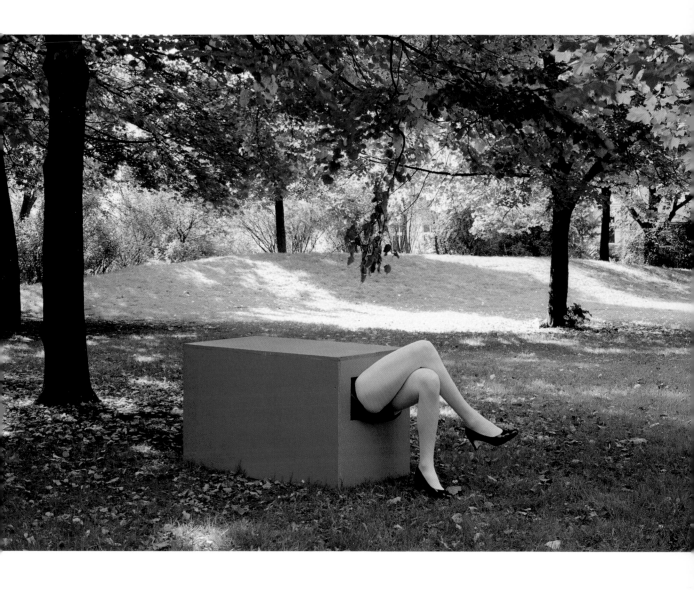

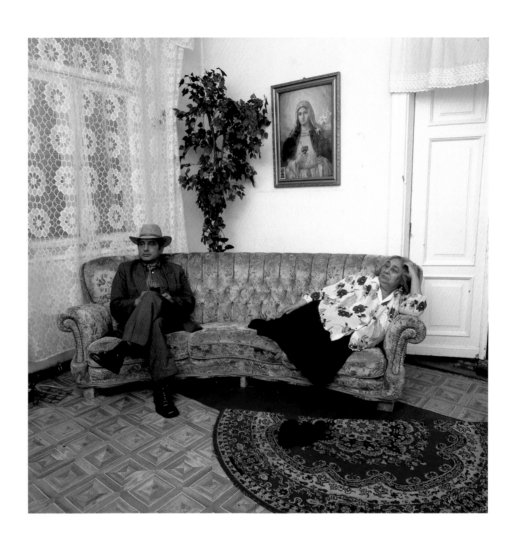

Payam Sharifi
Adela Gwinska and Family
From the series Gypsies Are For Real, with Igor Omulecki
C-type prints

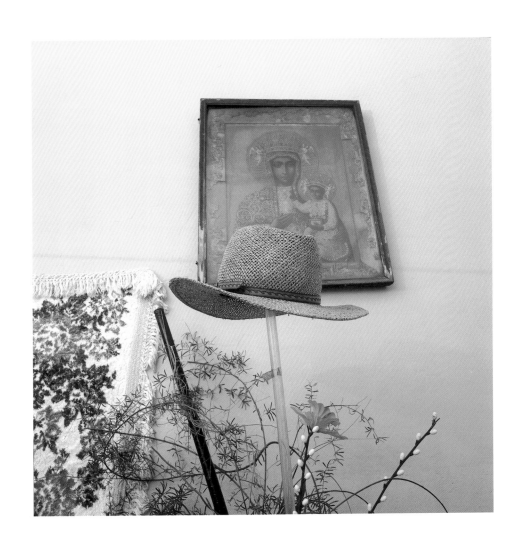

Gypsies are for real.

In the 70s and 80s, gypsies didn't exist in America. Having grown up in Texas, I thought they were as real as unicorns; characters one finds in books, movies, cartoons but never in the flesh. You don't bump into gypsies at the grocery store, in the gas station, or on the little league field. When I first noticed the extravagant, almost byzantine manors dotting the landscape outside Lodz, in central Poland, I knew that no matter how real gypsies were, they would remain for me pure fantasy.

Adel could only dream of owning what Andrzej has bought as a folly.

Depending on the situation, Adel has a choice of bat, saw or stick to protect himself, his family, and his 3 bedroom, 80 m2 flat in Zgierz. His house is a breathing still-life. A romany everyman, Adel has managed, with the help of his mother and his son, to add sparkles of the Indian subcontinent to an otherwise non-descript flat.

Andrzej is a Polak living the gypsy high-life of sorts. Stocky but sweet, he stands at a hefty 1m50 and is a cash-heavy 'biznesman' with a flare for eccentric real-estate. Roughly 6 years ago, Andrzej moved into the house of a 'gypsy king'. The gypsy king is in essence the local romany population's civic and economic leader. Given generations of hostility towards Romanies and their segregation from the general population, Andrzej's purchase of the heavily-connoted gypsy king's house amounts to an architectural masquerade. He might lack three fingers ("settled debts," he claims) but chutzpah he doesn't lack. His decision to maintain the gypsy king's interior and restore pieces where necessary brings Andrzej closer to the curator than to the indulgent, bandit decorator.

The manor's ornamental exterior makes it all the more fairy-talesque, matched only by the gypsy king's nouveau-riche sincerity in bringing together grand siècle, rococo, and lacquer furniture under one roof.

When I asked what had become of the gypsy king, Andrzej said very matter of factly: "He's gone to America, for bigger business."

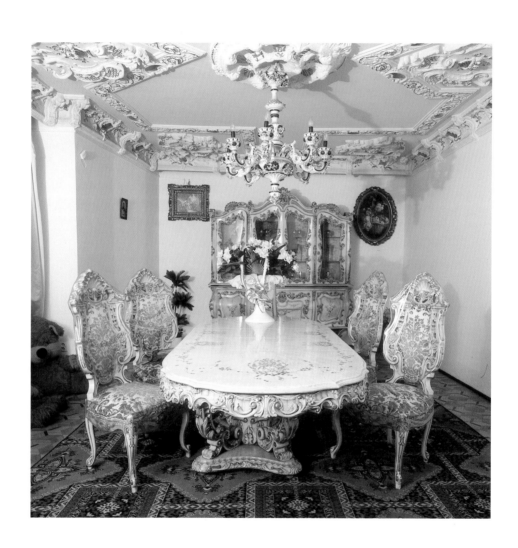

Payam Sharifi
Residence of Andrzej Marszalek
From the series Gypsies Are For Real, with Igor Omulecki
C-type prints

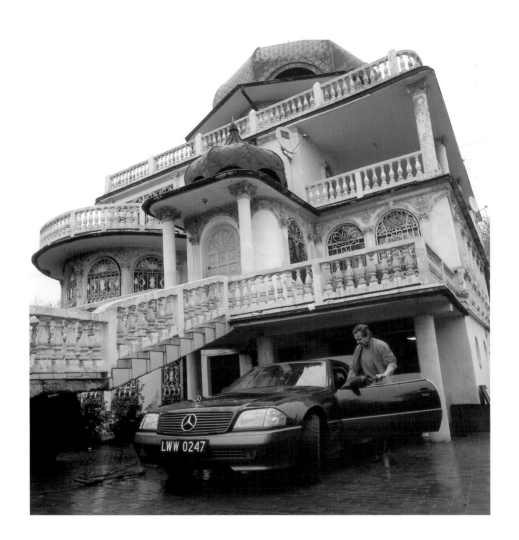

Chris Smith
Untitled
Oil on board

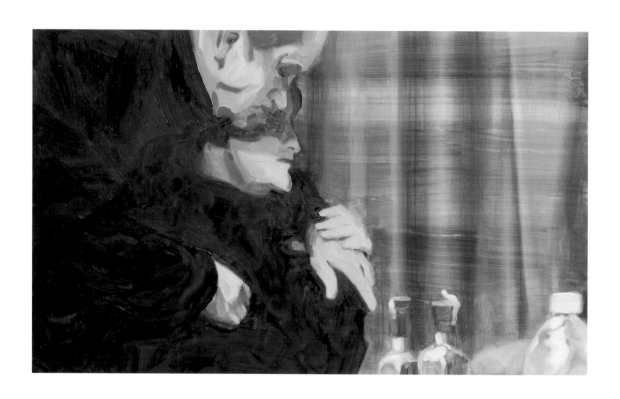

Chris Smith
Untitled
Oil on board

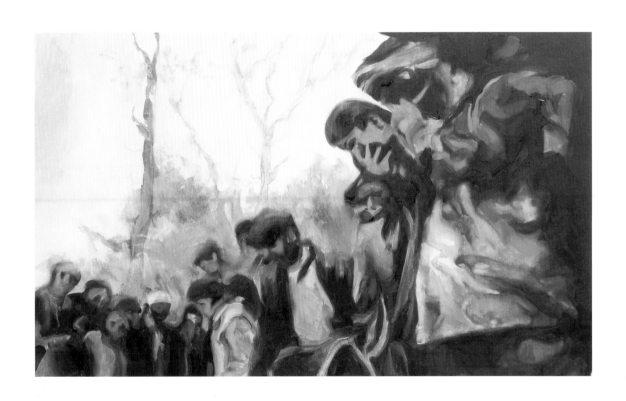

Chris Smith
Untitled
Oil on board

Robert Stone
Kate
Oil on canvas

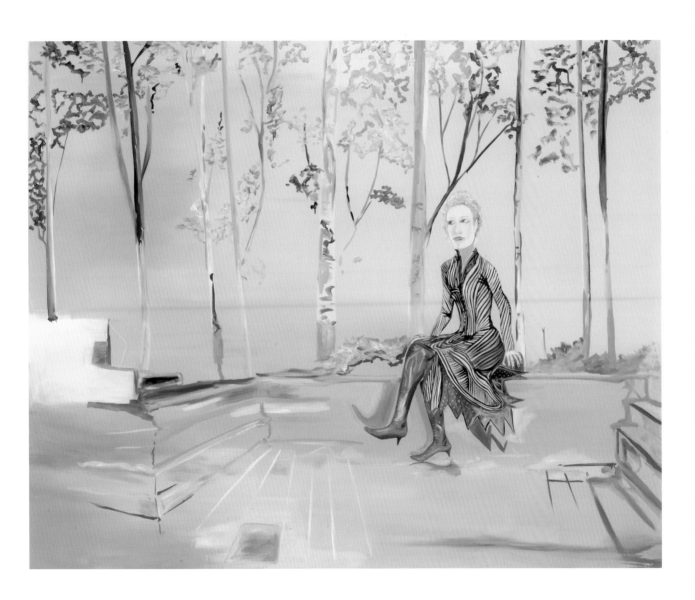

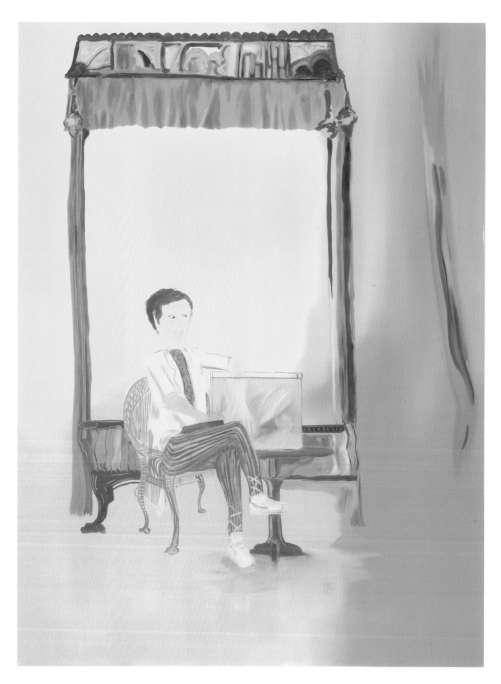

Robert Stone
Self Portrait at 28
Oil on canvas

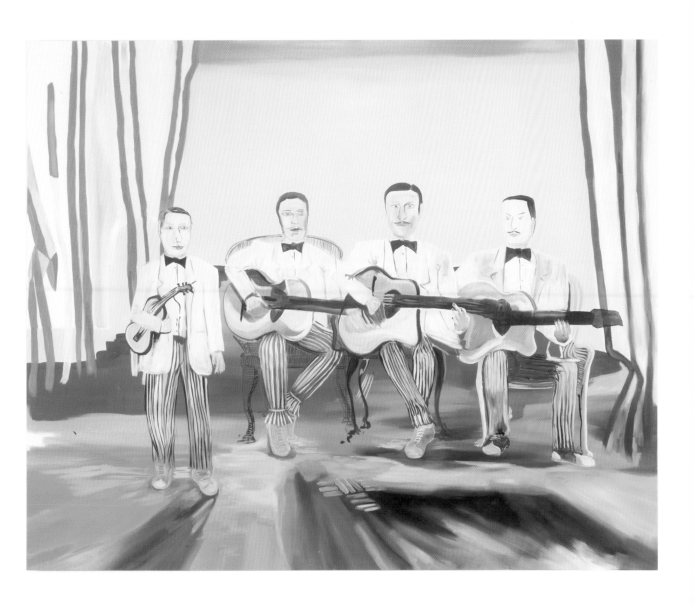

Robert Stone
After You've Gone
Oil on canvas

Christopher Walker
Spartan Habits and Spare Diet of a Soldier (left)
I Fructifier (right)
Wood and polystyrene
5ft x 2ft x 1.5ft and 3.5ft x 2.5ft x 2.5ft

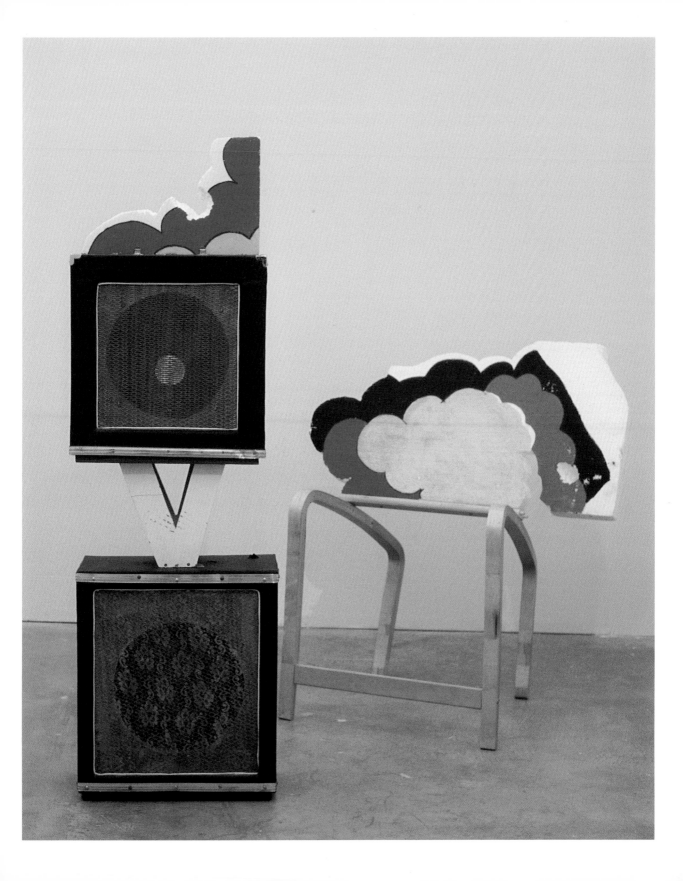

Craig Wilson
Boss and Dog – no up tae much
DVD
18mins

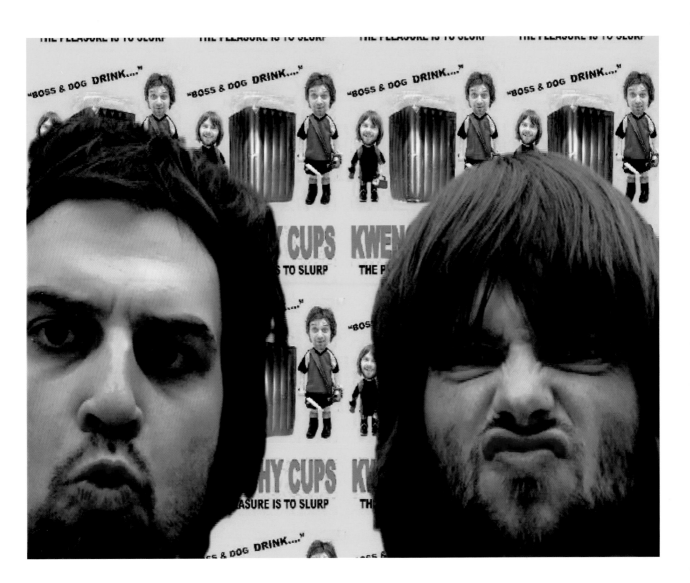

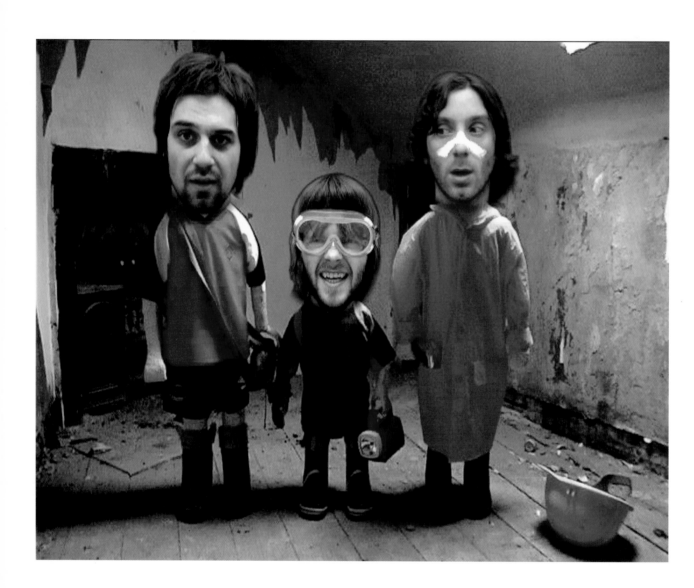

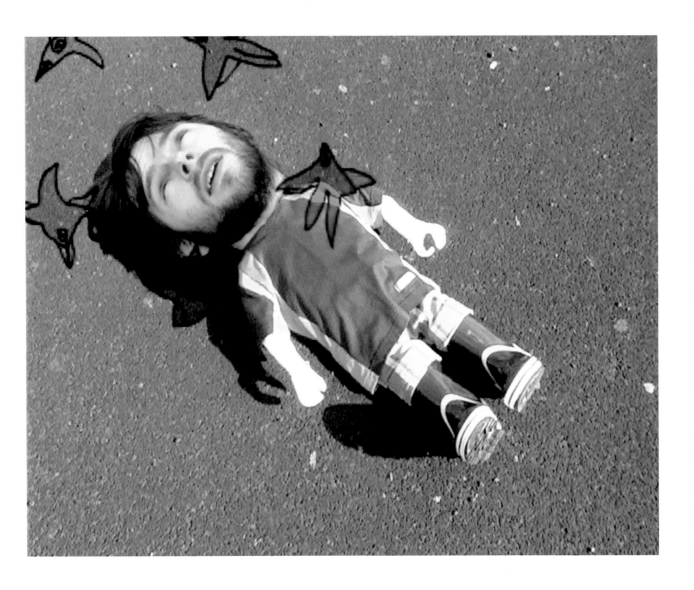

Mark Boulos

I have just graduated from the National Film and Television School with a MA in Documentary Direction, where I directed and produced five films over the past two years. Before NFTS, I lived in New York City, where I was a field worker and interviewer in the child welfare and criminal justice systems. During that time, I studied in Third World Newsreel's workshop, through which I produced and directed two shorts, and was also a member of the activist collective, Paper Tiger Televison, with whom I collaborated on two documentaries about American involvement in Middle East Politics.
Before that, I worked in independent feature film development and production for two years, and was the assistant to documentary director Errol Morris, my first job after graduating from college. I came to Errol after having studied philosophy at Swarthmore College in Pennsylvania and Deep Springs College in California. I was born and raised in Boston, USA by Syrian-Lebanese and Swiss parents. I now live and work in London.

Exhibits and Screenings
2004 Jerusalem, Shortlisted for Beck's Futures Student Award in Film and Video, screened at ICA, London. To be broadcast Channel 4.
2001 Self-Defense, Museum of Modern Art, New York, Documentary Fortnight, Galapagos, NY, The Culture Project, NY.

Dwight Clarke

B 1957 Hounslow, Middlesex

1985 BA (hons) Fine Art, Middlesex University
2004 MA Fine Art, Central St Martins School of Art and Design, London
1990-1998 Pop Video Film Director for various acts including Blur and Radiohead
Recording Artist as part of band Baby Fox released two albums and four singles on Road Runner Records Polygram

Recent Exhibitions
2005 Pearlfisher Gallery, London
2005 Temporary/Contemporary, London Flea Market
2004 Toilet Gallery, Kingston

Craig Coulthard

B 1981 Rinteln Military Hospital, West Germany

2004-2006 MFA Painting, Edinburgh College of Art
1998-2002 BA (hons) Fine Art, Edinburgh College of Art

Recent Exhibitions
2005 Unpacking My Library, University of Flensburg, Germany
2005 Craig Coulthard and Barry Maclaren, Patriothall Gallery, WASPS Studios, Edinburgh
2005 Collective Gallery Stand, Glasgow Art Fair
2005 The Embassy Collection II, The Embassy Stand, Glasgow Art Fair
2005 Fromage et Frottage, Evolution House, Edinburgh
2005 Conquests and Techniques, The Ship, Cable Street, London
2004 The Embassy Collection at Thermo 04, The Lowry, Manchester
2004 Amaryllis sillyramA, Glasgow Sculpture Studios
2004 The Embassy Collection, The Embassy Stand, Glasgow Art Fair
2003 Cash Generator, The Embassy at Cabin Exchange, Glasgow School of Art
2003 Thunder in Paradise, curated by Switchspace, Project Rooms, Glasgow
2003 Win Together Lose Together Play Together Stay Together, temporary artist run gallery and exhibition space, 28 Leven Street, Edinburgh
2002 Process, Bongo Club, New Street, Edinburgh
2002 Beyond the Fringe, Club Ego, Picardy Place, Edinburgh
2002 Out Now, Bongo Club, New Street, Edinburgh

Nelson Crespo

B 1975 Singen, Germany

2003-2004 Master of Arts in Printmaking, Camberwell College of Art, London
1999-2002 Fine Arts Honours, Escola Superior de Artes e Design of Caldas da Rainha, (ESAD), Portugal
1994-1997 Sculpture Bachelor, Escola Superior de Artes e Design of Caldas da Rainha, Portugal

Recent Exhibitions
2005 The Centre for the Study of Political Graphics, Los Angeles, USA
2005 Paper Politics, Seattle, USA
2005 Modern Nature curated by Mel Gooding, London Institute
2004 RK Burt Gallery, London
2004 Antecip'Arte 2004, Estufa Fria, Lisbon, Portugal
2004 100 Views of Tokyo and London, Tokyo Station Gallery
2003 Centro Cultural Emerico Nunes, Sines, Portugal
2002 Museo do Hospital e das Caldas da Rainha, Portugal
2002 Galeria Arquivo, Leira, Portugal

Katie Davies

B 1979 Southampton

2001-2005 MA Fine Art, Sheffield Hallam University
1997-2000 BA (hons) Metalwork and Jewellery Design,
Sheffield Hallam University

Recent Exhibitions
2005-2006 Artist's Residency and Visiting Lecturer, Kookmin
University, Seoul, South Korea
2005 POP, The HUB (Formerly the National Centre for Popular
Music), Sheffield
2004 Reactor Relaunch Event, Broadway Cinema, Nottingham
2004 STAGED Film Screening, Focal Point Gallery, Southend
2004 Host Cinema Project, Showroom Cinema, Sheffield
2003 TactileBosch, Cardiff

Jenny Dunseath

B 1978 Rugby

2002-2005 Postgraduate Diploma Sculpture, Royal Academy
Schools, London
1998-2001 BA (hons) Fine Art, Winchester School of Art

Recent Exhibitions
2005 Here nor There, Pompal, Brittany, France
2004 Bursary Show, Royal Society of British Sculptors,
London
2004 Premiums, Royal Academy of Art, London
2002 Withy River, Somerset
2002 What if we were Wrong, Spike Island, Bristol
2002 Wish you were Here, Bristol
2002 6, Somerset
2001 Silent Mill, Somerset

Erica Eyres

B 1980 Winnipeg, Canada

2002-2004 MFA, Glasgow School of Art
1998-2004 BFA (hons), University of Manitoba

Recent Exhibitions and Screenings
2005 Film Screening, curated by Adam Budd, Paved Arts,
Saskatoon Saskatchewan Film Pool, Regina
2005 Artificial Light, Film Screening, SAW, Ottawa
2005 Gifts of Sound and Vision, Glasgow International, 20 St
Andrews
2005 RCCA Spring Animal Show, Park Circus, Glasgow
2005 Bloc, curated by Bowieart, White Space Gallery, County
Hall, London
2004 It's for the Best, Dwarf Gallery, Reykjavik
2004 'neath the green green grass of home, Mary Mary,
Glasgow
2004 hang in there feral kitty, Glasgow Project Room,
Glasgow
2004 Herald Feminist Film and Video Festival, Calgary
2004 Cardboard Factory, The Leisure Club Mogadishni,
Copenhagen
2004 Braveart, Atrium Gallery, Whiteleys, Bayswater, London
2004 Toronto Art Fair, with the othergallery, Toronto
2004 Portobello Film Festival, Bowieart, London
2004 Antimatter Underground Film Festival, Victoria, Canada
2003 International Contemporary Drawing, The Gallery of the
Academy of Fine Arts, Guangzhou and touring Beijing and
Xi'an, China
2003 Split Film Festival, Split, Croatia
2003 Garage Film Festival, Strasuland, Germany
2003 Film Independent Festival des Arts, Montreal, Canada

Josephine Flynn

B 1975 Manchester

2003-2005 MA Fine Art, Sheffield Hallam University
1995-1998 BA (hons) Fine Art, Leeds Metropolitan University

Recent Exhibitions
2004 Now Then Now Then, International 3, Manchester
2003 Last Few Days, Leeds
1998 Manifesta 2, Casino Luxembourg

Andrew Graves

B 1967 Rochford

2005 MA Fine Art, Middlesex University
1987-1990 BA (hons) Fine Art, Kingston University

Recent Exhibitions
2005 Galerie Kusseneers Antwerp, Belgium
2004 Unique Sensationalle, Factor 44, Antwerp, Belgium
2004 Group Show, Tea Building, Shoreditch, London

Anne Kathrin Greiner

B 1975 Weinheim, Germany

2003-2005 MA Photography, Royal College of Art, London
1998-2002 BA (hons) Photography, Film and Imaging, Napier University, Edinburgh
1996-1997 BA Modern European Languages, The University of Edinburgh

Recent Exhibitions
2005 Gone in 60 Seconds, The Gallery by the Lake, Southwark Park, London
2005 Photography 2005, Gulbenkian Gallery, Royal College of Art, London
2004 Anne Kathrin Greiner:Landscapes, Kyoto-Arts, Kyoto
2004 Black and Light, Mailbox Gallery, Kyoto
2004 Vision 2004, London
2004 Disciplined Spaces, Tidal Wave Gallery, Exposure 2004, Hereford Photography Festival
2004 Made in London, European Parliament, Brussels
2003 Secret, Gulbenkian Gallery, Royal College of Art, London
2003 Lens-based Open, Surface Gallery, Nottingham
2002 ...and you will know, The New Street Exhibition Space, Edinburgh
2001 20"x24" Polaroid Photographs, Scottish National Portrait Gallery, Edinburgh

Hideko Inoue

B 1975 Osaka, Japan

2002-2004 MA Fine Art, Glasgow School of Art
1994-1998 BA Fine Art, Kyoto Seika University, Kyoto, Japan

Recent Exhibitions
2005 When I Lived in Modern Times, Northern Gallery for Contemporary Art, Sunderland
2005 from there to here/soko kara koko e, Gallery Sowaka, Kyoto, Japan
2005 Places Seen, Glasgow Print Studio
2005 Exposition de Printemps 2005, Centre de Creation, Le Village Bazouge la Perouse, France
2004 Autokineticism, Glasgow Print Room
2004 Braveart, Atrium Gallery, Whiteleys, Bayswater, London
2004 Internationalism, Royal Concert Hall, Glasgow
2003 Hitch, Glasgow Print Studio
2002 Kokyo-Glasgow/Kisaichi, Glasgow Print Studio
2002 New Works, Gallery Lavender, Kobe, Japan

Takahiro Iwasaki

B 1975 Hiroshima, Japan

2005 MA Fine Art, Edinburgh College of Art
1998-2003 BA (1998), MA (2001), PhD, (2003) Hiroshima City University, Japan

Recent Exhibitions
2005 Differential/Integral Calculus, Sleeper Gallery, Edinburgh
2005 Dudelsack, Deutzer Brucke, Cologne, Germany
2004 Konran Show, Okada Studio, Nagoya, Japan
2004 Recent Work, Evolution, Edinburgh
2004 Occasion, Big Park, Edinburgh
2004 RSA Exhibition, Royal Scottish Academy, Edinburgh
2004 Beyond the City, Sleeper Gallery, Edinburgh
2003 Process to Model, Formative Space Laboratory, Hiroshima
2003 Recent Work, Inverleith House, Edinburgh
2002 Art Image of Hiroshima, Hiroshima City Museum of Contemporary Art
2002 Recent Work for 4, Daiwa Radiator Factory, Hiroshima
2001 Reflection Model, Gallery Natsuka b.p, Tokyo

Elizabeth Lee

B 1964 Kidderminster

2001-2004 BA (hons) Fine Art, Birmingham Institute of Art and Design, University of Central England

Recent Exhibitions
2004 Targetmaster, BIAD, Birmingham
2004 Balloontastic, Margaret Street, Birmingham
2003 Music and Art Collaboration with Birmingham Conservatoire
2002 How Many Artists, The Works Gallery, Birmingham
2001 Omega, The Custard Factory, Birmingham

Stuart McCaffer

B 1966 Banbury

2001-2004 BA (hons) Sculpture, Edinburgh College of Art

Recent Exhibitions
2005 cane and abel summer of '69, Extention, Glasgow
2005 Monarch of the Glen, Market Gallery, Glasgow
2004 My Family and Other Animals, Traverse, Edinburgh
2004 Care Bear, Crawford Art Gallery, Cork
2004 Doing Bird, Royal Scottish Academy
2003 Ken the Dug, Traverse Theatre, Edinburgh
2002 Artists Against War, The Roxy, Edinburgh
2001 Trig-Point, Blackford Hill, Edinburgh

Richard Mosse

B 1980 Republic of Ireland

2004-2006 MA Fine Art, Goldsmiths College, University of London
2002-2003 MRes Cultural Studies, London Consortium
1998-2001 BA (hons) English Literature and Language, Kings College, London

Recent Exhibitions
2005 International Artist Workshop, Palestinian Ministry of Culture, Ramallah
2004 Commonground, Artsway, New Forest
2004 Open #20, Café Gallery Projects, London
2004 HYPERLINK www.seesawmagazine.com
2004 Seminal, Static Gallery, Liverpool
2004 It Went Dark and I Saw, London College of Communication
2003 The Movement, Static Gallery, Liverpool
2003 The Object Conference, Tate Modern, London
2003 Solo Exhibition, Camden People's Theatre, London
2002 Observer Hodge Award, Guardian Newsroom, London

Clive Murphy

B 1971 Wexford Town, Republic of Ireland

2002-2004 MA Fine Art, University of Ulster, Belfast

Clive Murphy is a Belfast based artist whose work ranges sculpture, installation, public interventions.

Recent Exhibitions
Hugh Lane Gallery, Dublin
Crawford Municipal Gallery, Cork
Union Centre for Art, Toronto
Alma Enterprises Gallery, London
INSA Centre for Contemporary Art, Seoul
The Greek Centre for Art, Shanghai
British Council commission in collaboration with CityMine(d), Brussels
Coney Island Project, Creative Time, NYC
Visonic, Ormeau Baths Gallery, Belfast
Matchmaking at Suzhou Creek, Eastlink Gallery, Shanghai
China-OK! Gallery 411, Hangzhou
Veneer/Folheado, Zedebois Gallery, Lisbon
Made In China, Context Gallery, Dublin
Golden Mile Project, c/o Fully Formed Art Projects, Belfast
Destruction or Deliverance, Jenapardes Gallery, Munich
Fresh Fruits, Pallas Heights, Dublin

Beltran Obregon

B 1964 Barcelona, Spain

2003-2004 MA Fine Art, Goldsmiths College, University of London
2002-2003 Postgraduate Diploma in Fine Art, Goldsmiths College, University of London
1985-1988 BA Industrial Design, Rhode Island School of Design, USA

Recent Exhibitions
2005 Stress Positions, ICA, London
2004 Copy-art.net, ICA Project Room, London
2004 Beating About the Bush, South London Gallery
2004 Time Pop 2004, Prince Charles Cinema, London
2002 Busan Biennale, Busan, Korea
2002 Leisure Theory, Jumex Collection, Mexico
2001 Mach, Galeria Santafé, Planetario Distrital, Bogota, Columbia
2001 De Donde Vienen las Cosas, Galeria Valenzuela y Klenner, Bogota, Columbia
2000 Transcripciones y Translaciones Edificantes, Galeria Valenzuela y Klenner, Bogota, Columbia

Bruno Pacheco

B 1974 Lisbon, Portugal

2003-2005 MA Fine Art, Goldsmiths College, University of London
1996-1999 BA (hons) Fine Art, Goldsmiths College, University of London
1993-1996 Lisbon School of Fine Art, Lisbon University

Recent Exhibitions
2005 Uniao Latina Prize, Centre of Modern Art, Gulbenkian Foundation, Lisbon
2004 Can You Paint Me A Picture, Haunch of Venison, London
2004 Constant Differences, Museum of Modern Art, La Spezia, Italy
2004 In Between Two Lights, Centre of Modern Art, Gulbenkian Foundation, Lisbon
2004 Lisboa 20 Gallery, Lisbon
2004 Time Pop 2004, Prince Charles Cinema, London
2003 FA Projects, London
2002 Slow Motion, curated by Miguel Wandshneider, ESTGAD, Caldas da Rainha, Portugal
2001 Moving Still, Dilston Grove, London

Robert Orchardson

B 1976 Glasgow

2003-2004 PGDip Fine Art, Goldsmiths College, University of London
1994-1998 BA (hons) Fine Art, Duncan of Jordanstone College of Art and Design

Recent Exhibitions
2005 Beyond, Monitor Gallery, Rome
2004 Symmetriad, Galerie Ben Kauffman, Munich
2004 Friday Night, All Saints Church, London
2004 Half of Life, Galerie Ben Kauffman, Munich
2004 Crystal Peaks, S1 Artspace, Sheffield
2003 Knights of the Holy Contact, Intermedia Gallery, Glasgow
2002 Earthly Paradise, Cooper Gallery, Dundee
2002 News From Nowhere, The Changing Room, Stirling
2001 Beyond, Dundee Contemporary Arts
2001 Members Show, Transmission Gallery, Glasgow
2000 Forever, Dundee City Airport

Giles Perry

B 1969 London

2002-2004 MA Fine Art, Goldsmiths College, University of London
1995-1998 BA (hons) Fine Art, Central St Martins School of Art and Design, London

Recent Exhibitions
2005 13+, Domo Baal, London
2005 Biennale! Artists Film and Video 2005, Temporary/Contemporary, London
2004 Avvistamenti-underground video, Politeama Italia, Bisceglie
2004 Off LOOP 04, Barcelona
2004 Yesvember, House Gallery, London
2004 Bone Quake, 16 Upper Wimpole Street, London
2004 All Tomorrow's Parties, Yugoslav Biennial of Young Artists, Galerija Zvono, Belgrade
2004 Ready Steady Go, Three Colts Gallery, London
2004 Thirtysecondslivequake, Galerie Jacky Strenz, Berlin
2003 Intervention, John Hansard Gallery, Southampton
2003 Definitively Provisional, Whitechapel Project Space, London
2002 Discourski, Galeria Arsenal, Bialystok
2001 Predator, KX. Kampnagel, Hamburg

Muzi Quawson

B 1978 London

I graduated from the Kent Institute of Art and Design in 2001. To date, my work has gained recognition and awards through the Guardian Student Awards, Fuji Awards, London Photographic Award, L.P.A-5 and the Metro Imagery Bursary. My work has been published in several publications including Crash magazine, K Magazine and The Telegraph on Saturday. I have exhibited in the former Hackney Downs Secondary School, University of Canterbury, Speak for Gallery Tokyo, Jousse Enterprise Paris and the Royal College of Art London. I have been commissioned by Grey Worldwide Ltd, Random House and Guardian Umlimited with my collective Documentography, to document the 2004 American Election. I am studying Fine Art Photography at the Royal College of Art, graduating in 2006.

Charlotte Rea

B 1982 Shoreham-on-Sea

2001-2004 BA (hons) Photography, Manchester Metropolitan University

Recent Exhibitions
2003 Faith, Cambridge Artworks, Cambridge
2003 Monitor: An Investigation into Surveillance, The Northern Quarter Gallery, Manchester
2003 Collective Behaviour, Manchester Cathedral
2003 EGO, Victoria Baths, Manchester

Jaume Simo Sabater Garau

B 1972 Maria de la Salut, Majorca

2003-2005 MA Fine Art Sculpture, Royal College of Art, London
2002-2003 MA Media Research, Ecole Superieur des Beaux Arts, Geneva, Switzerland
1996-1998 MPhil Aesthetics, UPV, San Sebastian, Basque Country
1991-1996 BA Fine Art, UPV, Bilbao, Basque Country

Recent Exhibitions
2005 Peripheral Visions, curated by Nigel Rolfe and Cliodhna Shaffrey, Cork Film Centre, Cork, Ireland
2004 Cantaferro, Horrach Moya Gallery, Palma de Mallorca
2004 El Paisaje: Lo dado y lo Interminable, curated by Sebastia Camps, Horrach Moya Gallery, Palma de Mallorca
2004 Stereo White, curated by Nigel Rolfe, Royal College of Art, London
2004 Art School, curated by Sacha Craddock and Keith Wilson, Bloomberg Space, London
2002 Art Jove 2002, Espai Ramon Llull, Palma de Mallorca
2002 Panem et Circenses, Can Gelabert, Binissalem, Mallorca

Martina Schmuecker

B 1973 Munich, Germany

2003-2005 MA Fine Art Sculpture, Royal College of Art, London
1998-2002 BA University of the Arts, Berlin

Recent Exhibitions/ Performances
2005 Architectural Week, Camden Arts Centre, London
2005 Let Me Hear Your Body Talk, Arti et Amititiae, Amsterdam
2004 Stereo White, Royal College of Art, London
2004 Besame Mucho, Performance Night, Hoxton Hall Theatre, London
2003 Durchzug, Stiftung Starke, Lowenpalais, Berlin
2003 Vorbilder, Friedrich Wilhelm Universitat, Bonn
2002 Club Transmediale Berlin, E-werk, Berlin
2002 Projektraum Aroma, Berlin
2002 Kunstsommer Oberhausen, die Garage, Oberhausen
2001 Project Space, Mondovisione, Berlin
2000 Projecto de arte e peregrination, Santiago de Compostela, Spain

Payam Sharifi

B 1976 Austin, Texas, USA

2005 MPhil, Royal College of Art, London
1998 BA, Columbia University, New York
1997 St Petersburg State University, Russia
1996 Universite de Paris III, France

Recent Exhibitions
2005 Proud and Sad, Wrong and Strong, Women and their Work, Austin, Texas
2005 Official Selection, FIAMH, Villa Noailles, Hyeres, France
2004 Selfish, 128 Rivington, New York
2004 Borne of Necessity, Weatherspoon Art Centre, Greensboro, North Carolina
2003 Somewhere Totally Else, London Design Museum
2003 Emergencias, Casa Encendida, Madrid
2002 Official Selection, Stockholm International Film Festival, Sweden
2002 Hall of Fame, Fanclub, Amsterdam

Chris Smith

B 1964 Bradford, West Yorkshire

2001-2004 BA (hons) Fine Art, University of Gloucestershire

Recent Exhibitions
2004 Residency and Exhibition, Hans Brinker Hotel, Amsterdam
2003 Hans Brinker Trophy, Amsterdam
2003 British School of Rome, Summerfield Scholarship
2003 Framed Works for the Future, Pittville Pump Rooms, Cheltenham
2000 3 At The Borlase, Borlase Gallery, Oxfordshire

Robert Stone

B 1981 London

2003-2005 MA Fine Art, Slade School of Fine Art, University College London
2000-2003 BA (hons) Fine Art, Kingston University

Recent Exhibitions
2004 Summer at Cassland, Hackney, London
2003 Spread, Century Gallery, Cremer Street, London

Christopher Walker

B 1980 Edinburgh

2002-2004 MFA, Edinburgh College of Art
1998-2002 BA (hons) Fine Art, Edinburgh College of Art

Recent Exhibitions
2005 Solo Exhibition, The Commissary, Edinburgh
2005 ESW/ECA Bursary Award, Edinburgh Sculpture Workshop
2005 Born Under a Bad Sign, Collective Gallery, Edinburgh
2004 Magazine, Edinburgh Sculpture Workshop
2004 Tonic to the Nation, Duncan of Jordanstone College of Art and Design

Craig Wilson

B 1973 Bellshill, North Lanarkshire, Scotland

2004-2005 MSc Electronic Imaging, Duncan of Jordanstone College of Art and Design
1998-2000/2002-2004 BA (hons) Time Based Art, Duncan of Jordanstone College of Art and Design

Recent Exhibitions
2005 Beck's Futures, Student Film and Video Award, ICA London and touring
2005 Circus Circus, Park Circus, Glasgow
2005 Catalyst Arts, Belfast
2005 N.R.L.A., Arches, Glasgow
2005 The Halloween Short Film Festival, ICA, London
2005 Scottish Students On Screen, CCA, Glasgow

Acknowledgements

Bev Bytheway
Administrator

Somehow, on a diet of endless packets of crisps, nuts, fruit, biscuits, chocolate, coffee, tea, water, wine, bread and cheese, and then some more, the selection is arrived at. If anything, the selection process is the one thing that makes New Contemporaries unique. It is a process, as democratic as it can possibly be, where the voices of the selectors respond to the call of the work. Each year, the system remains the same, the difference lies with the team of selectors. It is the Board of New Contemporaries who choose the selectors, it is the selectors who choose the work. Each year has its own character, though it is never possible to characterise. Special thanks are due to Jeremy Akerman, Phil Collins and the Wilson Twins who made this year's selection such an enjoyable experience and collectively have arrived at a strong and mature show. Thanks too to the team of helpers, who are so essential to the process, led by Tom Chamberlain.

The exhibition launches at Cornerhouse, Manchester. Cornerhouse is loyal in its support of New Contemporaries, providing a regular venue since 1989. We are pleased to be part of their 20th Anniversary celebrations and thank Dave Moutrey, and Kathy Rae Huffman for their commitment to us.

Then, it's Bristol, in a collaboration between the artist-run space LOT and Spike Island. The Bristol showing is initiated by two artists who have previously shown in New Contemporaries themselves, Kieran Brown and James Ireland. We look forward to bringing New Contemporaries to Bristol, with their help. Thanks to Sally Shaw and Lucy Byatt.

The 2005 exhibition returns to the The Curve Gallery at the Barbican in November. Our remembrances are with Carol Brown, who was responsible for setting-up the original partnership with the Barbican. The Barbican's support extends to providing generous spaces and all the necessary technical equipment for selection, as well as a London home for the exhibition. Thanks to Mark Sladen, Alona Pardo and Graz Kalenic.

New Contemporaries is a very special project, not least for all the selected artists. It is their opportunity to be seen, to meet their fellow artists, curators, organisers, to be exposed to a range of venues and their practices, to have their work looked at and be discussed. Hopefully it gives them a start.

None of this would be achieved without the funding of the Arts Council and the sponsorship of Bloomberg. We are indebted to Bloomberg who support the principles of New Contemporaries without question and to the Arts Council North West.

ISBN 0 9540848 5 3

Published by New Contemporaries (1988) Ltd
© New Contemporaries (1988) Ltd and the artists

Catalogue edited by Bev Bytheway

Photography: Stephen White
All other images supplied by the artists

Design: AW assisted by DL @ www.axisgraphicdesign.co.uk
Print and Reprographics: Andrew Kilburn Print Services and Scan Plus

sponsored by
Bloomberg

afoundation